THE JACKSON 500™ VOLUME ONE

TIM BISKUP

Publisher
MIKE RICHARDSON

Editor
PHILIP SIMON

Designers
TIM BISKUP with DARIN FABRICK

Dark Horse Books
A division of Dark Horse Comics, Inc.
10956 SE Main Street
Milwaukie OR 97222

darkhorse.com

To find a comics shop in your area, call the Comic Shop Locator Service toll-free at 1-888-266-4226.

First edition: June 2005
ISBN: 1-59307-355-0

10 9 8 7 6 5 4 3 2 1

Printed in China

For **SEONNA** With Love

Thanks To: Seonna, Tigerlily, Mary & Stefan Biskup, Steve & Pamela Henry-Biskup, Mike & Lisa Biskup, Dee & John Lockwood, The Hong Family, Craig & Jolene Myers, Greg Long & Stacy Stevens, Chris Edmundson, Sean Kelly & Catherine Foulkes, Miyoko & Aaron Nather, Mark Ryden & Marion Peck, Gary & Mel Baseman, Long Gone John, Evan Mack, Todd & Kathy Schorr, Glenn Barr, Josh Agle, Camille Rose Garcia, Bwana & Marny Spoons, Martin Ontiveros, Jeff & Stacy Mann, Mark Todd & Ester Pearl Watson, Shepard & Amanda Fairey, Andrew Brandou, Miles Thompson, Eric & Michelle Bryan, Dalek, Jonathan Levine, Billy Shire, Tom Hazelmyer, Martin McIntosh, Jay & MiShell Nailor, Mark Parker, Alix Sloan, Jamie O'Shea, William Haugh, Jeremy Andrew, Monte Beauchamp, Ron & Colin Turner, Juliette Torrez, JJ Abrams, Raymond Choy, Hugo Stevenson, Conor Libby, Colin Batty, Yasutaka & Maki, Stuckie, Paul Cruikshank, Craig Thompson, Michael Martens, David Scroggy, Philip Simon & Everyone At Dark Horse, Animation Friends (too many to mention). I'm sure I'm forgetting someone & I'm sorry!

IT'S THE END OF THE WORLD, BUT TIM BISKUP ISN'T GIVING IN!

By Craig Thompson

His paintings are smothered with frantic, gurgling chaos: shrieking birds, goggly-eyed gimps, skulls, explosions, acid rain, monsters, struggling bunnies, and smoking monkeys.

It's an apocalyptic landscape, to be sure ... mirroring much of the terrifying, inhumane world we live in.

In the face of impending doom, it's easy to surrender to nihilism or defeatism, to grow hopeless and retire. To be sure, Tim was once a misdirected slacker, describing himself as "extremely prolific ... at drinking beer and playing video games."

But somehow, he learned to channel this frustration with a destructive society into constructive energy. It didn't happen overnight. For nearly four years, he drew five hours a day and discarded all the results —just to whip his art skills into shape. Then he got into the ring, feisty and hyperactive, letting the images, as he describes it, "flow out like blood."

Tim says he has a very comfortable, Zen perception of the end of the world. It's always the end of the world. For ages, mankind has been worn dizzy with violence, exploitation, and brutality, but, as Tim points out, our world is simultaneously a gushing wellspring of love.

And how evident this love is in Tim's work, all painted with such grace and beauty and giddy, giggling cartoon slickness!

Is it scary? Is it cute? It's an end-of-the-world anthem with a danceable beat.

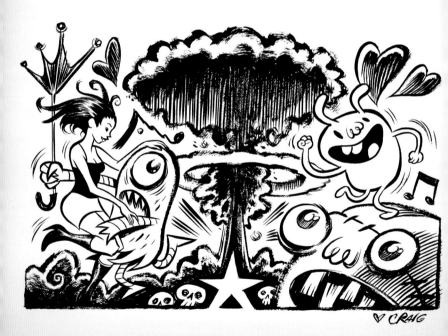

... STILL PAINTING WHEN MY HEAD HITS THE PILLOW

By Tim Biskup

My hand is cramped. My eyes are blurry. I can't remember what number I'm working on.

There's a movie on TV that I wish I could actually watch, but I can't because I'm caught up in this little blue creature that just came out of my brain ... but I guess I'm following along enough to know that the guy in the black suit just killed somebody and he's trying to cover it up before his boss finds out and I wonder if this blue guy has anything to do with the way the sky looks outside his window between the trees ... no, wait ... I'm looking out *my* window. It's starting to get light outside. Damn ... what time is it?

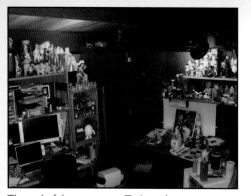

That colorful crime scene: Tim's studio

I've got to get to bed, but I'd better finish this guy's eyes because I may forget that I wanted to use that color right there that I mixed for the wings on that bird in the other painting that I put over there. What number was that one? Actually, it kinda needs something between that flower and the guy with the knife sticking out of his head. Maybe a star. I could use this blue that I used for the little view-outside-the-window guy.

Oh, man! The guy's boss just walked in and he's covered in blood and the body is right there on the floor sticking out from behind the chair and there's something

about that shape that I like. I could use that shape as a hat on the head of the monster that is carrying the bomb in the painting that was just right there next to my beer about an hour ago. I wonder if that beer is still cold ...? I shouldn't drink that thing anyway, because it's 5:22 A.M. and the sun is coming up.

All right, forget it. I'm going to bed. I roll over to Seonna's desk and kiss her goodnight. She's working on an animation background that she has to turn in tomorrow, and it looks really great. She's sad that I'm going to bed and that she has to stay up for another twenty minutes that will probably stretch into an hour.

Man ... I gotta sleep.

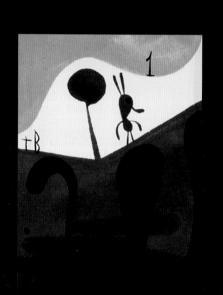

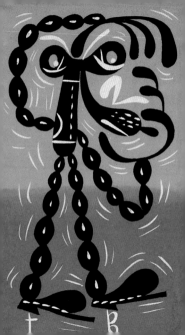

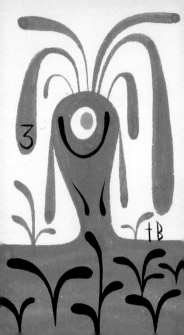

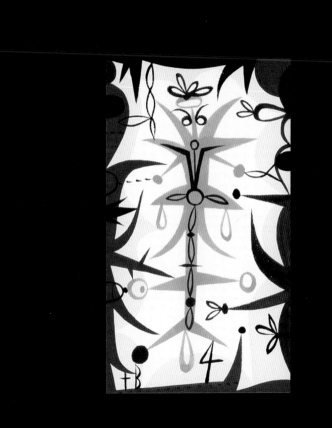

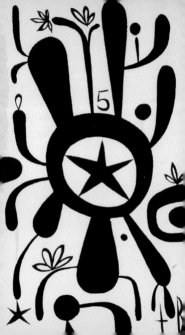

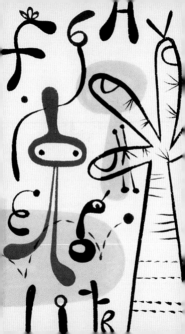

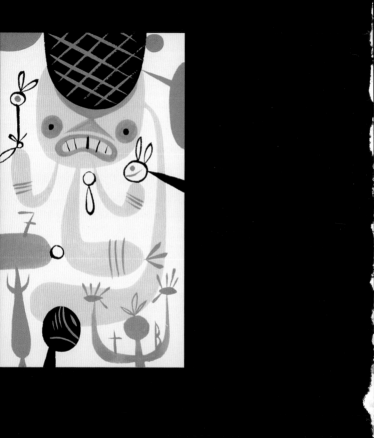

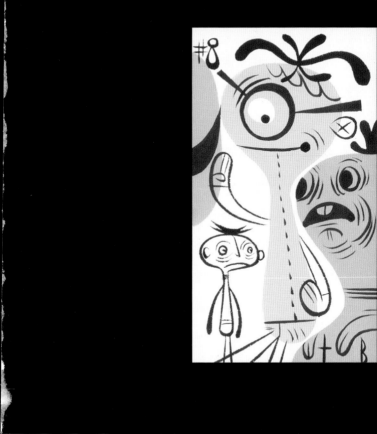

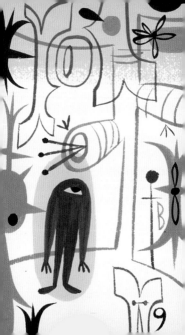

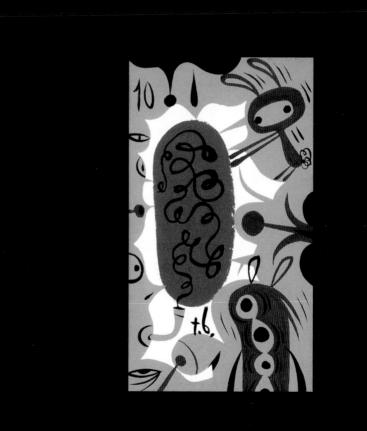

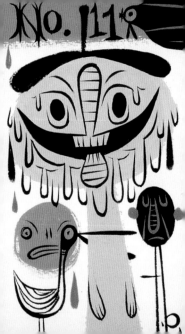

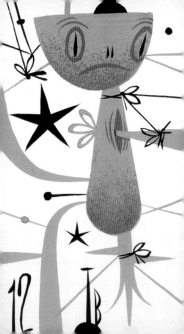

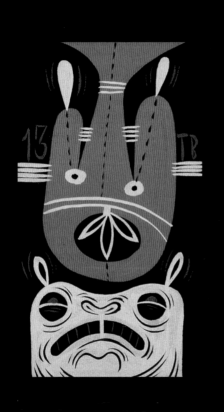

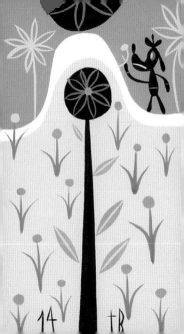

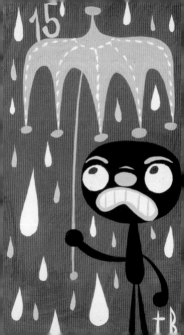

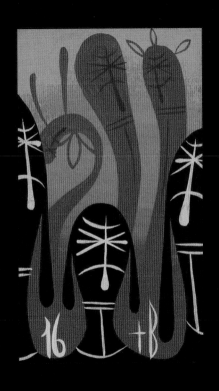

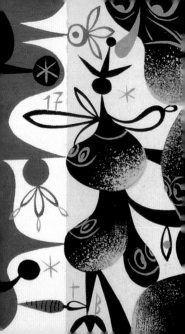

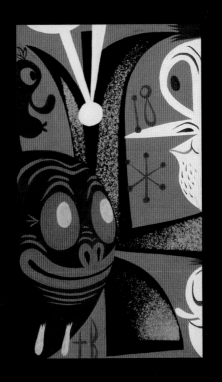

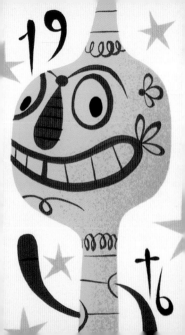

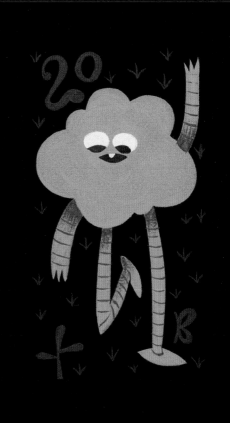

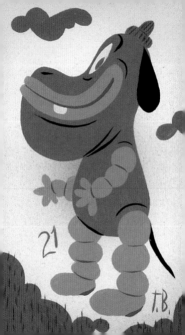

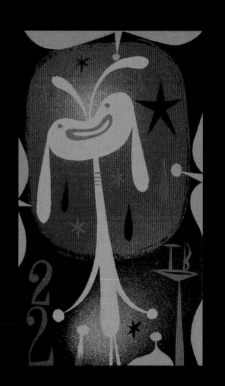

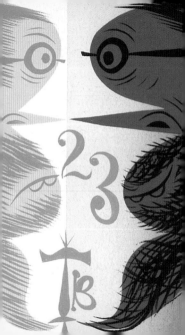

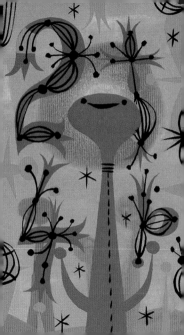

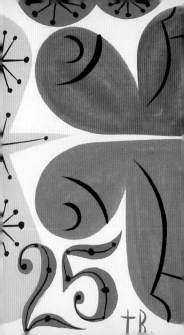

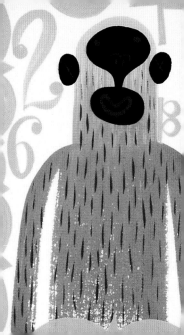

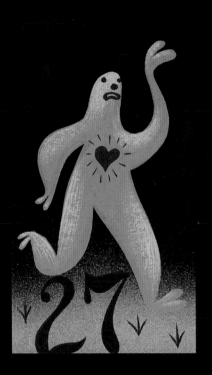

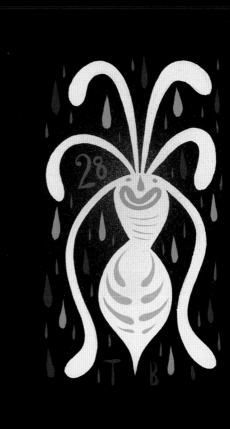

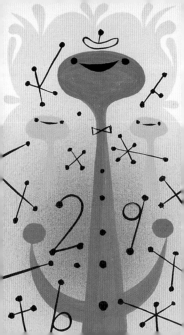

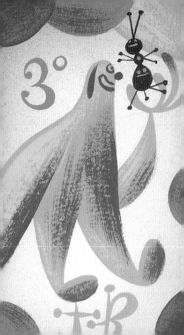

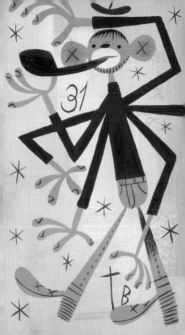

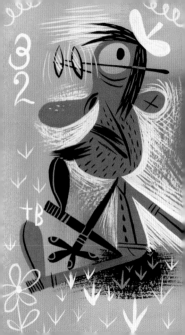

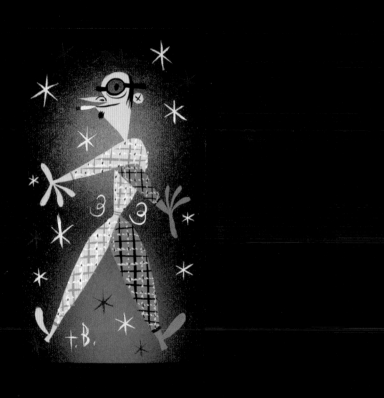

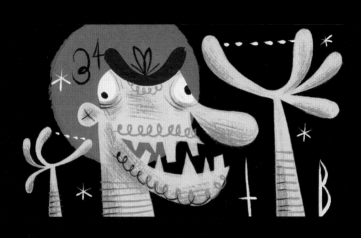

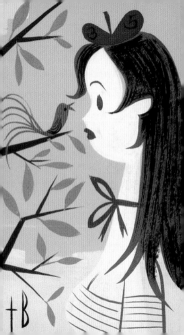

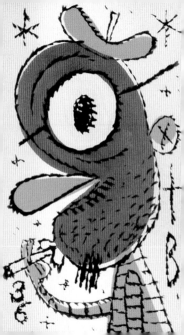

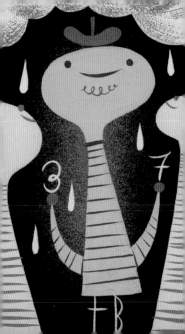

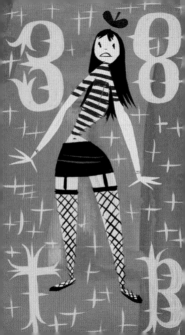

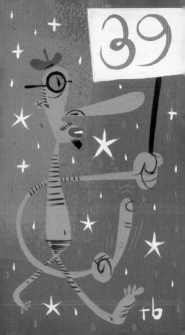

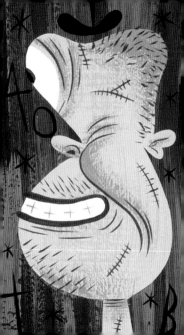

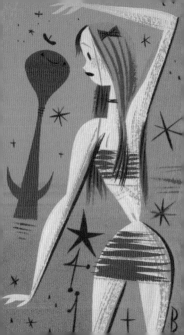

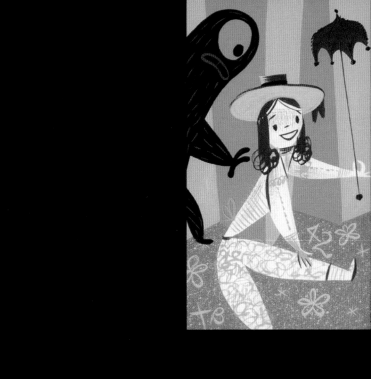

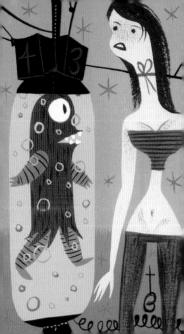

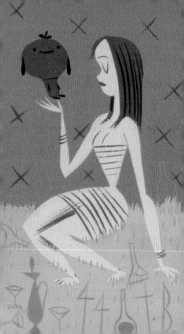

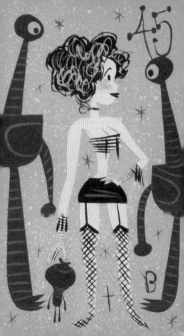

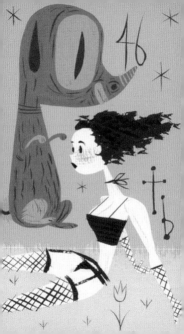

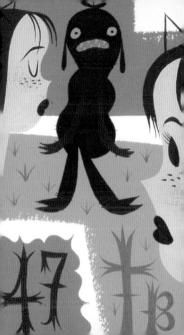

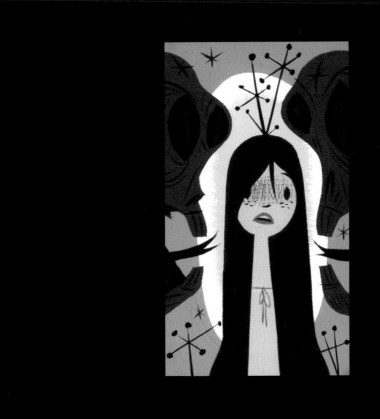

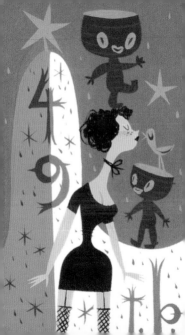

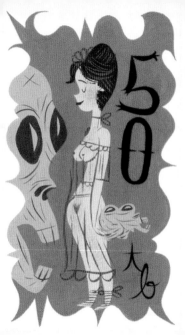

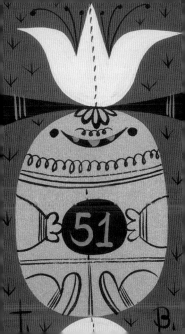

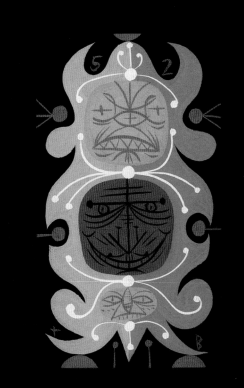

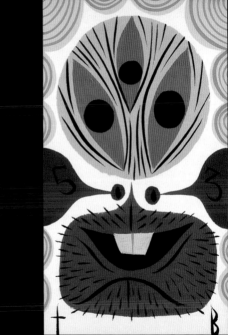

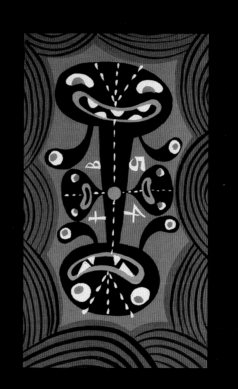

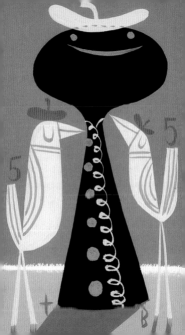

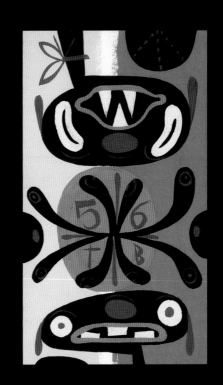

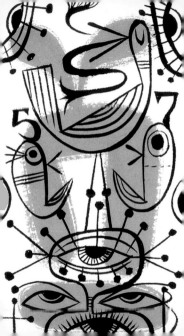

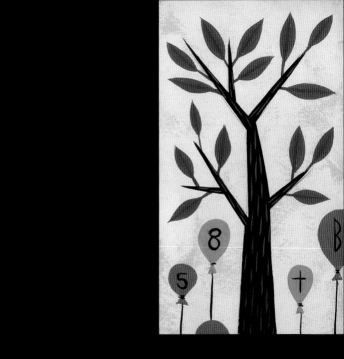

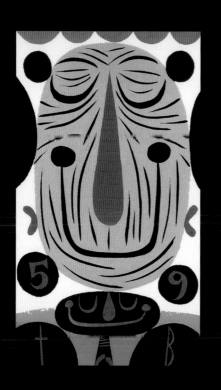

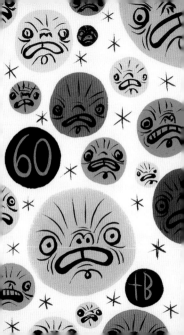

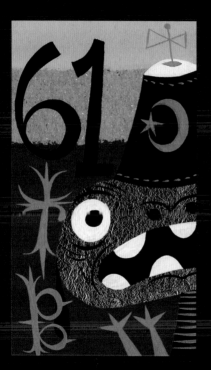

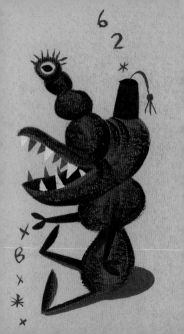

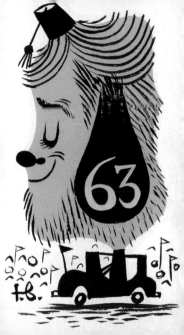

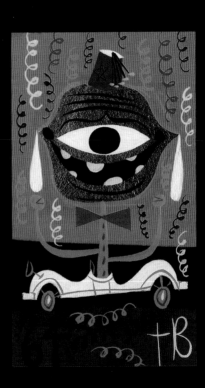

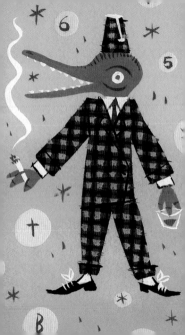

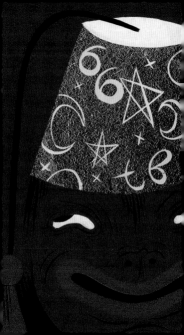

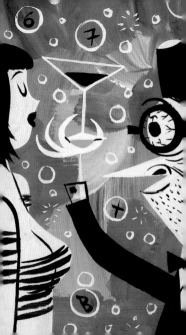

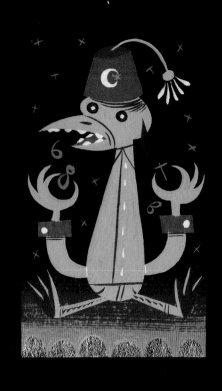

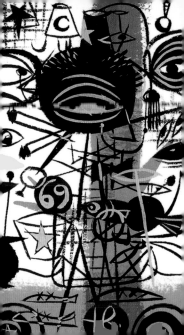

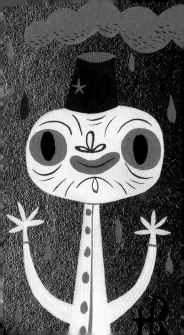

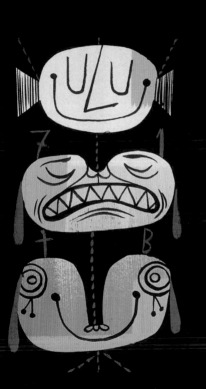

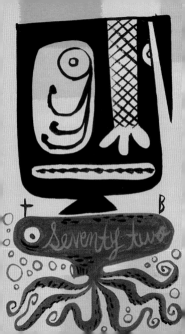

seventy two

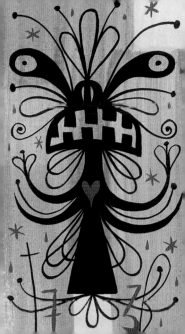

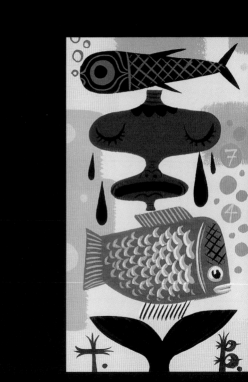

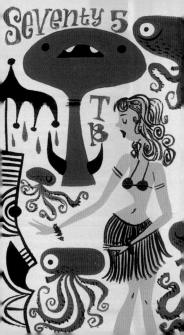

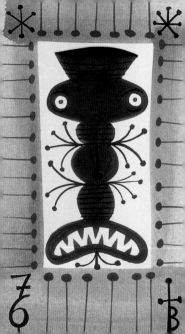

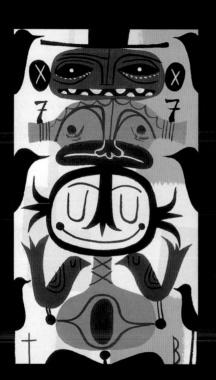

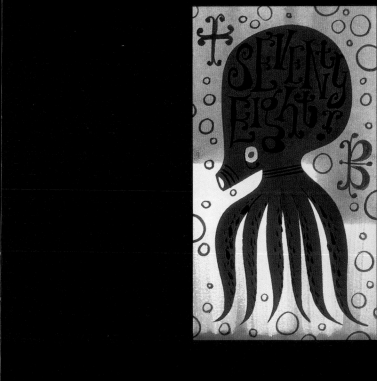

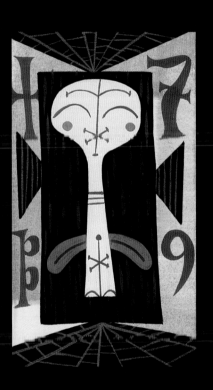

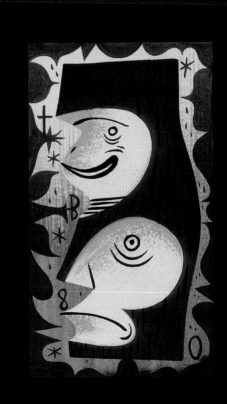

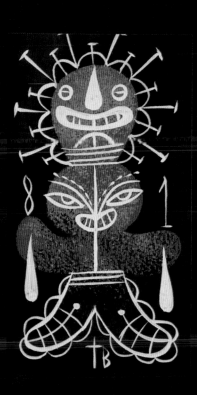

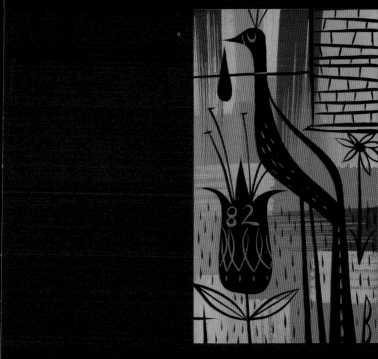

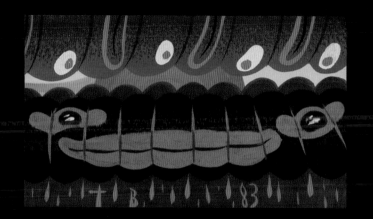

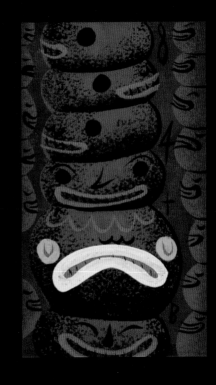

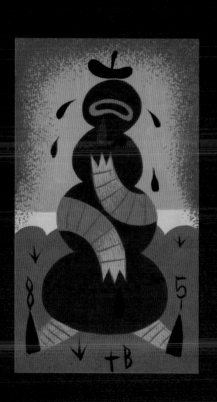

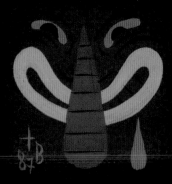

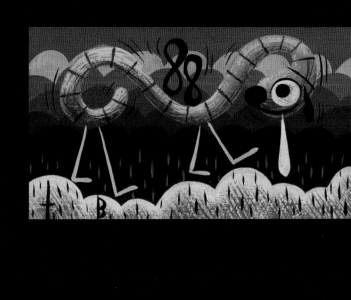

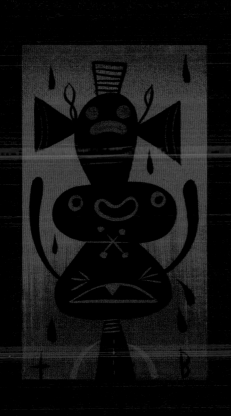

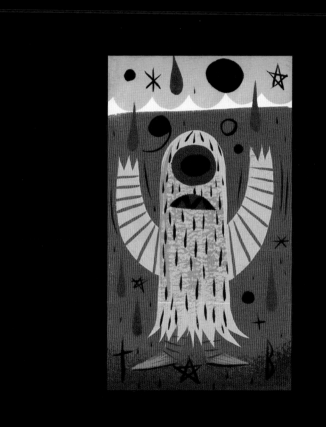

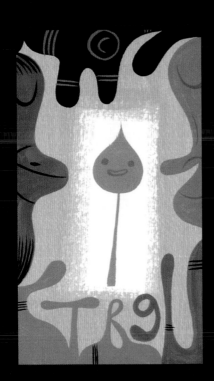

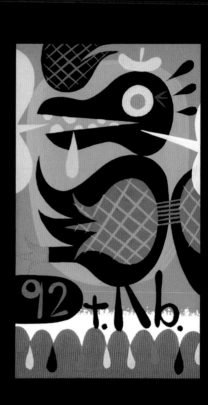

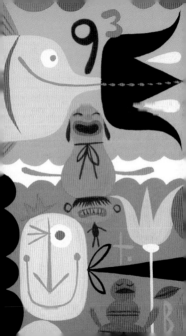

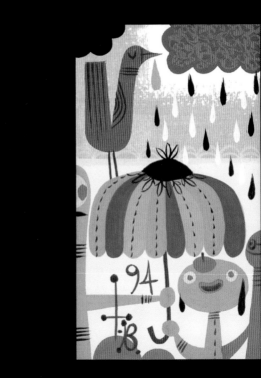

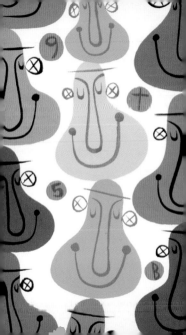

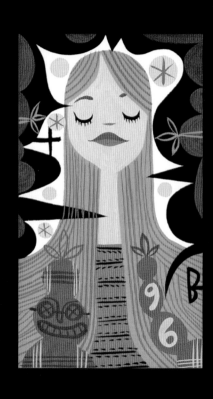

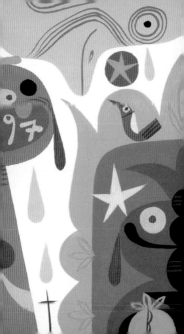

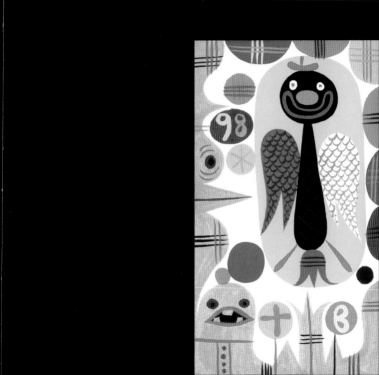

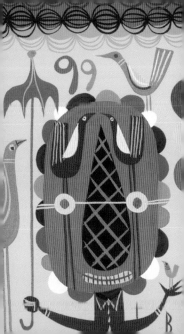

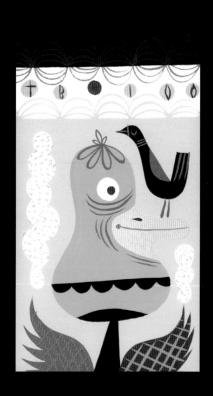

JACKSON 500 VOLUME ONE, EXHIBITION HISTORY:

1 - 10 were never shown publicly. They were sold to individual private collectors. May, 2003.

11 - 20 were included in *Alphabeast*, a solo exhibition of paintings, prints, and objects at La Luz De Jesus Gallery in Los Angeles, California. June, 2003.

21 - 30 were shown at Orbit Gallery, Edgewater, New Jersey. July, 2003.

31 - 40 were included in *Beatsville*, a beatnik-themed group show and book published by Outré Gallery Press, Melbourne, Australia. December, 2003.

41 - 50 were included in *The Phantom Thread*, a solo exhibition of paintings, prints, and objects at OX-OP Gallery in Minneapolis, Minnesota. September, 2003.

51 - 60 were never shown publicly. They were sold through Flopdoodle.com. November, 2003.

61 - 70 were included in *Big Men In Little Cars*, a Shriner-themed group show at Tin Man Alley Gallery, Philadelphia, Pennsylvania. January, 2004.

71 - 80 were included in *I Dream Of Tiki*, a tiki-themed group show at M Modern Gallery, Palm Springs, California. May, 2004.

81 - 90 were shown as part of the grand opening of the Bispop Gallery. Pasadena, California. September, 2004.

91 - 100 were shown by Billy Shire Gallery at the Scope Miami Art Fair. Miami, Florida. December, 2004.

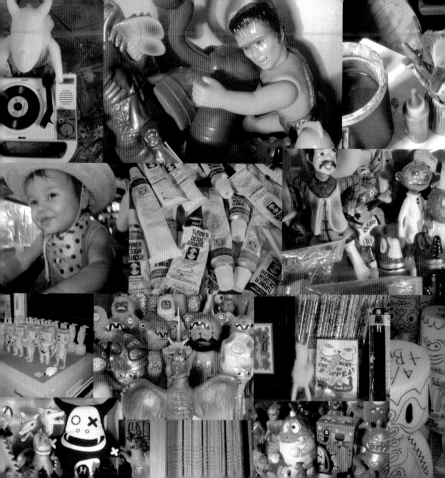

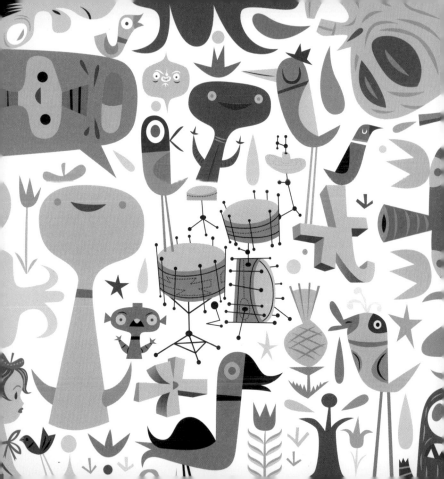